SuperVisions
STEREO OPTICAL ILLUSIONS

Al Seckel

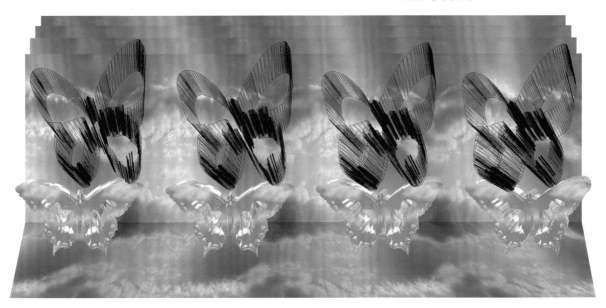

Sterling Publishing Co., Inc.
New York

Art credits, courtesy and copyright 2006 the artist:
Images pp. 6 – 13 — © 2006 IllusionWorks, L.L.C., drawn by Alice Klarke
Images pp. 17 – 36, 40 – 84 — © 2006 Gene Levine

Book Design: Lucy Wilner
Editor: Rodman Pilgrim Neumann

Library of Congress Cataloging-in-Publication Data
Seckel, Al.
 Supervisions : stereo optical illusions / Al Seckel.
 p. cm.
 Includes bibliographical references and index.
 ISBN 1-4027-1833-0 (alk. paper)
 1. Optical illusions. 2. Visual perception. I. Title.

QP495.S439 2006
612.8'4--dc22

 2005024042

 2 4 6 8 10 9 7 5 3 1

Published by Sterling Publishing Co., Inc.
387 Park Avenue South, New York, NY 10016
© 2006 by Al Seckel
Distributed in Canada by Sterling Publishing
c/o Canadian Manda Group, 165 Dufferin Street
Toronto, Ontario, Canada M6K 3H6
Distributed in the United Kingdom by GMC Distribution Services,
Castle Place,166 High Street, Lewes, East Sussex, England BN7 1XU
Distributed in Australia by Capricorn Link (Australia) Pty. Ltd.
P.O. Box 704, Windsor, NSW 2756, Australia

Printed in China
All rights reserved

Sterling ISBN-13: 978-1-4027-1833-5
ISBN-10: 1-4027-1833-0

For information about custom editions, special sales, premium and
corporate purchases, please contact Sterling Special Sales
Department at 800-805-5489 or specialsales@sterlingpub.com.

CONTENTS

INTRODUCTION

Although there have been many books that contain three-dimensional images and stereograms, this collection presents artistic and novel stereo images. Gene Levine, a southern California artist who specializes in three-dimensional images, created images especially for this collection.

Many stereo or "3D" illusions trace their origins to the discovery of stereograms by the English scientist Charles Wheatstone in 1838, after he noticed that the views entering each eye were different. Wheatstone showed that the retinal images from two independent sources could be fused into a single image, giving the immediate impression of depth. The effect was due to the difference of the images, not their similarity.

If you open your right eye and then your left, while keeping your head still, you will see different views. Hold up a finger about a foot away from your nose. See how the finger appears to move to a slightly different position relative to the background. Notice that there is an overlapping point of view from the two eyes. All animals possessing overlapping optical fields have depth perception. When the slight differences of the "flat" images are interpreted by your brain, a stereo view is perceived.

To make any type of stereo image, you must present two different viewpoints. Some are obvious, as in a stereo pair, and others are almost impossible to directly see, as in a hidden-image stereogram, known as a "Magic Eye" image. In all stereo images, your brain must combine the different viewpoints into a single 3D image.　　　　—Al Seckel

CHAPTER 1: IMPOSSIBLE ANAGLYPHS

Take out the red/blue anaglyph glasses that are at the back of this book. Make sure that the blue lens is over your right eye. Let your eyes relax when viewing the image, and it should appear three-dimensional. Don't forget to place the glasses back in the book when you are finished.

The images in this first chapter are impossible figures. Impossible figures suggest objects that are physically impossible to construct in three dimensions. Their constructions usually contain paradoxical and contradictory perspective cues. Historically, impossible figures have been depicted as simple line drawings or more complex paintings in perspective. Here, normal stereo techniques are applied to some simple impossible figures to give that added paradoxical third dimension.

The blue and red images form the two separate viewpoints. The red filter filters out the red, and the blue filter filters out the blue. For example, when looking at these red and blue images, look at the image through only the blue lens and you will see that the blue virtually disappears. Conversely, when you look through the red lens, the red lines will virtually disappear. In either case, the lines will not entirely disappear, so you may see "ghost" lines when viewing simple anaglyphs. But the background of these impossible anaglyphs will obscure this "ghosting," and it is even more obscured with more complex anaglyph images you will see in Chapter 2.

If you rock your head back and forth, the figure will similarly rock back and forth.

Impossible Blocks in Cube

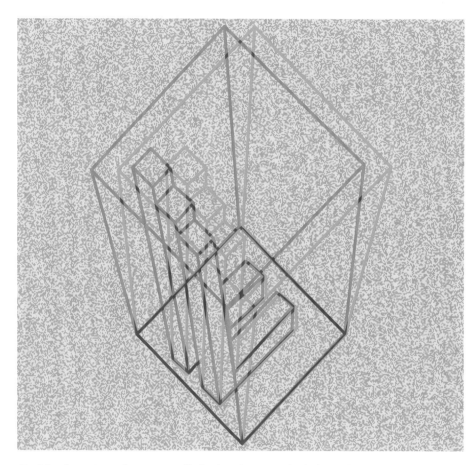

Inside the wire cube, you will find a figure, which has three bars at the top, which transform to only two at the bottom.

Impossible Towers

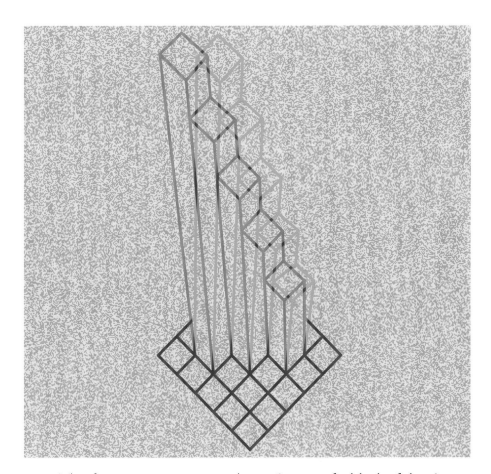

This figure contains two paradoxes. Can you find both of them?

Impossible Staircase

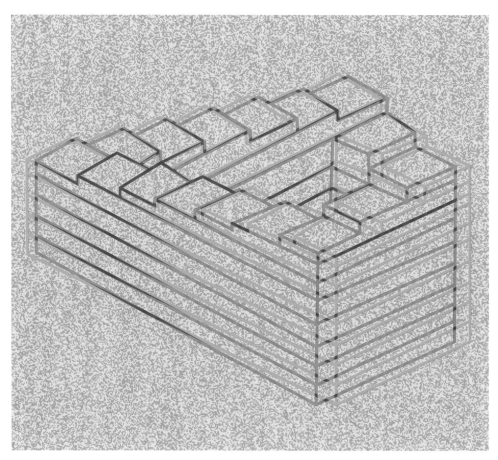

Can you find either the lowest or highest step of the stairs?

Impossible Triangle in a Cube

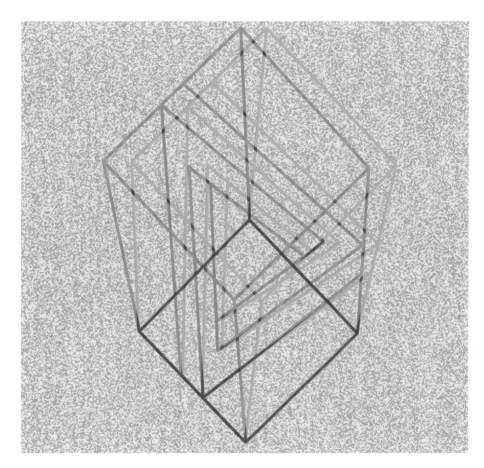

The impossible triangle, found inside the cube, is the most classic impossible figure. The limbs of the triangle simultaneously recede and come toward you, yet somehow they meet.

Impossible Lumber Pile

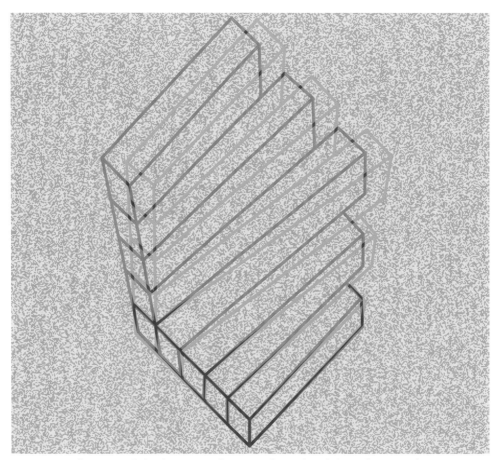

The tops of the bars transform to the side of the adjoining bar.

Impossible and Possible

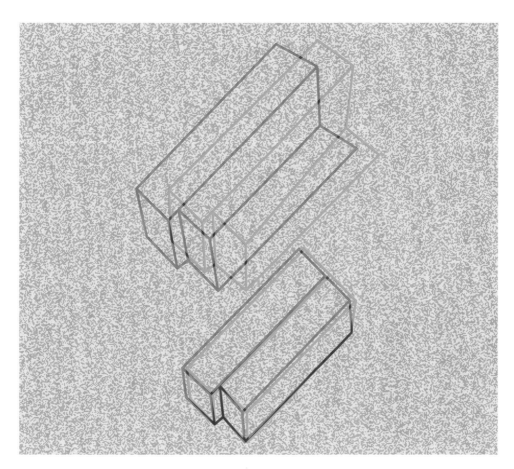

The top figure is impossible, but the bottom figure is quite possible.

Impossible Rectangle

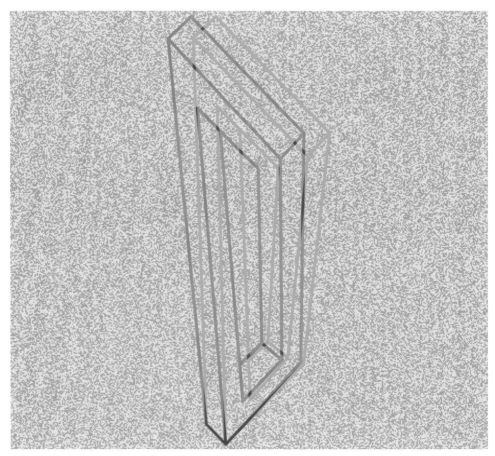

When you stretch an impossible triangle, you get an impossible rectangle.

Impossible Grid

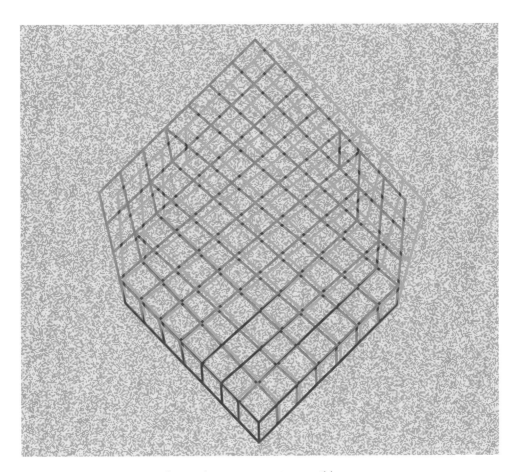

The grid rises in an impossible way.

Impossible Fork and Its Shadow

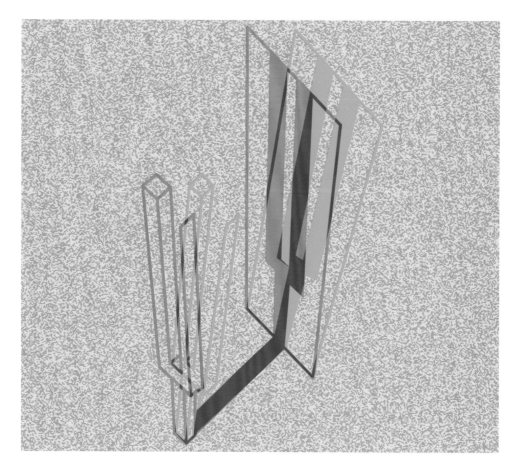

What would the shadow of an impossible fork look like?

Impossible Six-Pointed Star

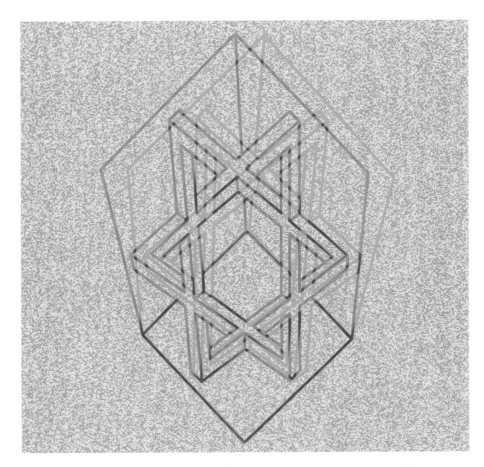

*This figure has six impossible triangles joined together to form
an impossible six-pointed star.*

Impossible Hypercube

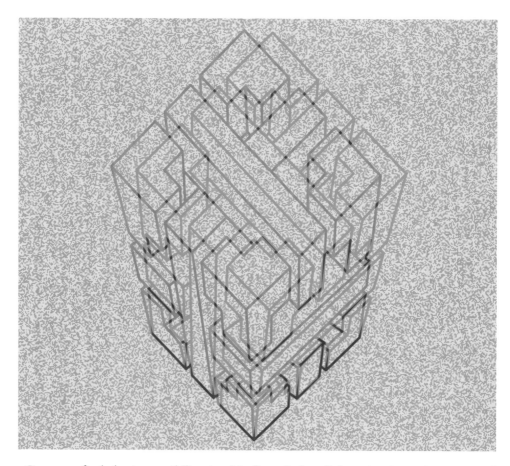

Can you find the impossibility in this figure? Swedish artist Oscar Reutersvärd designed the impossible figure on which this anaglyph is based.

CHAPTER 2: SPECTACULAR ANAGLYPHS

You will need to use your anaglyph glasses to see these images. They are viewd in the same manner as those in Chapter 1.

3D to 3D

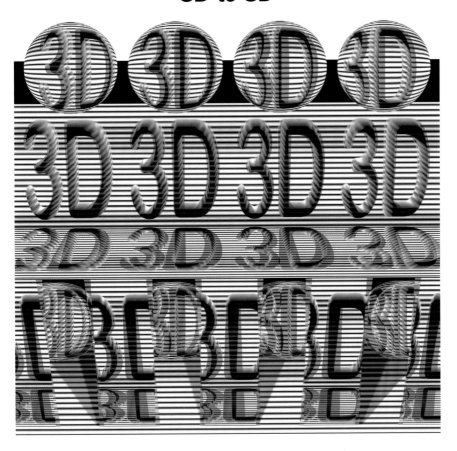

Sun Face

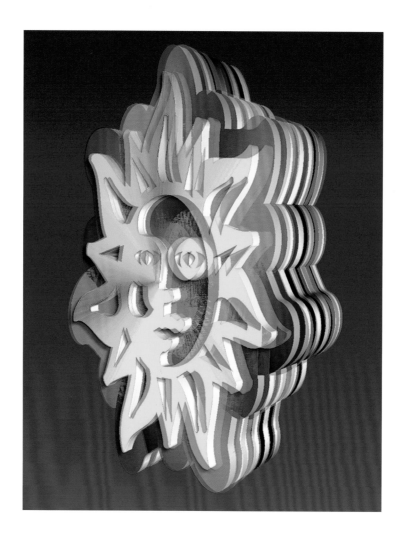

Backlight

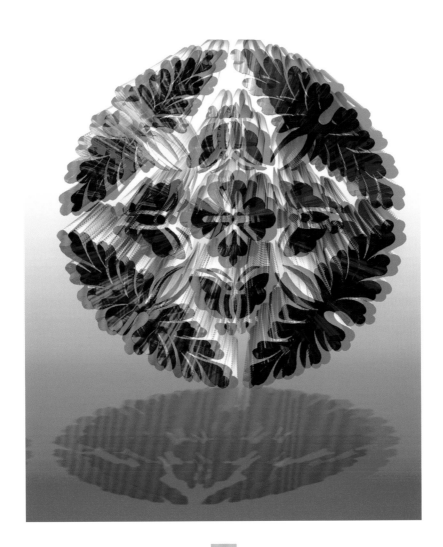

Blossom Waves

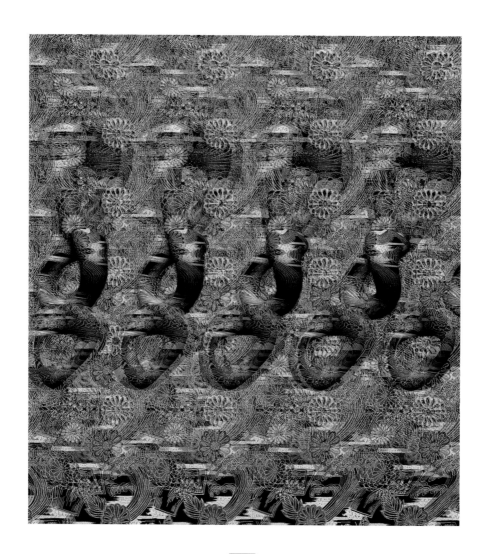

Orchid Terrace

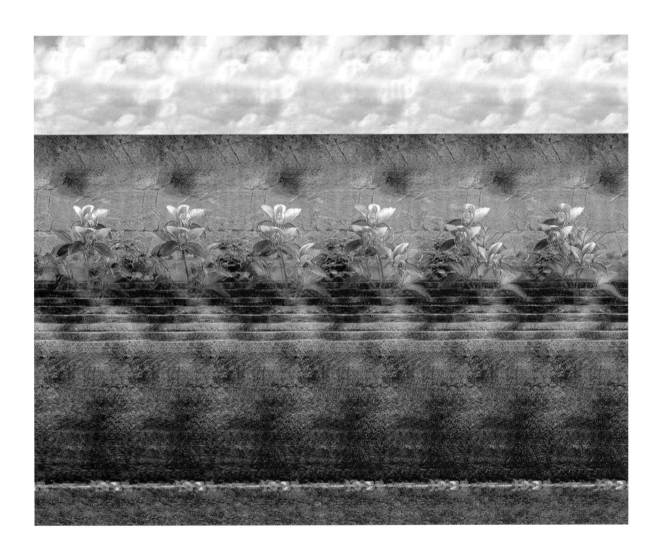

Crescent Moon

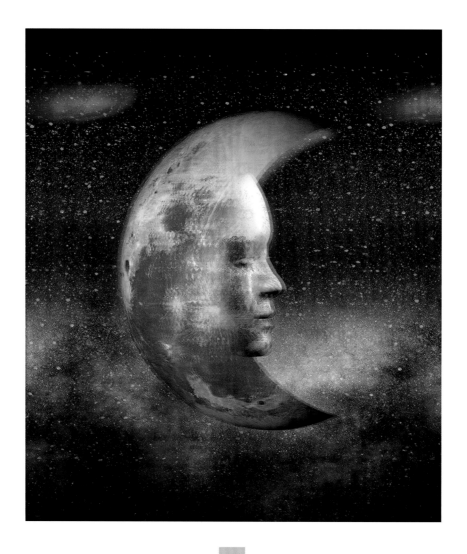

Donut Girl

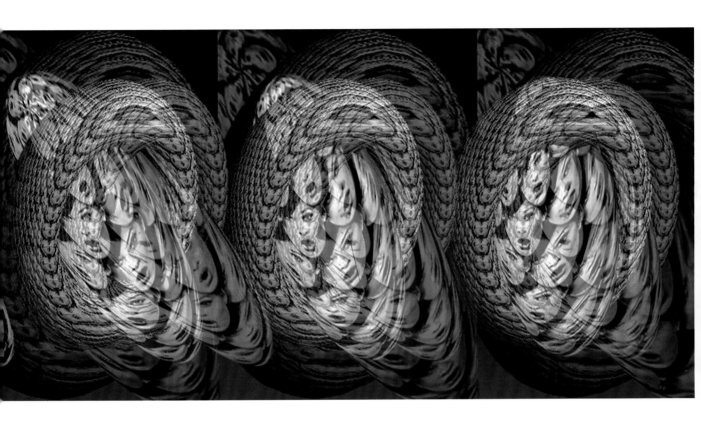

SUPER VISIONS: **Stereo Optical Illusions**

Dragon Light

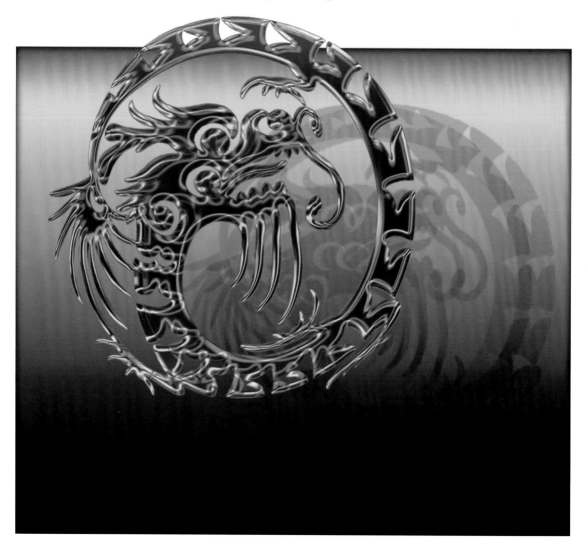

Egyptian Shadows

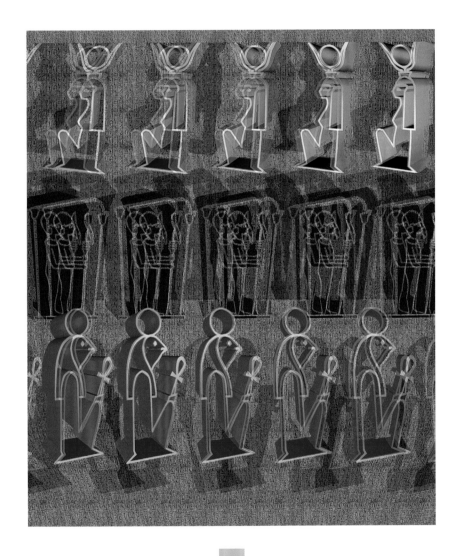

Eye Liner

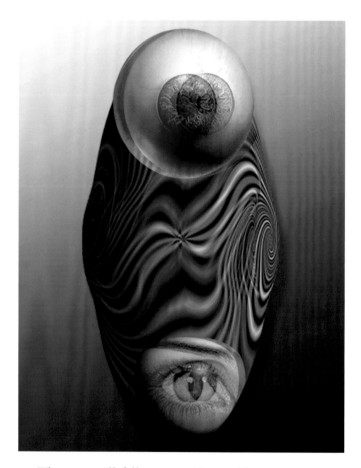

The eyes will follow you side-to-side as you move.

Feathers

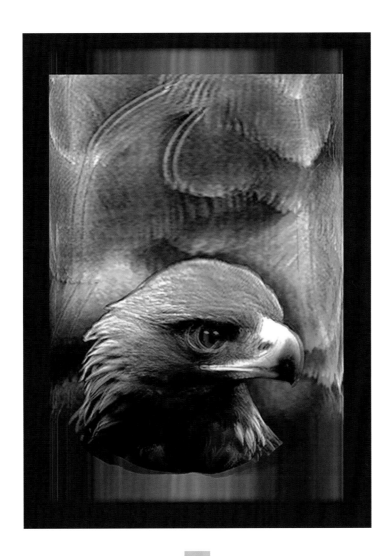

Lined Butterfly

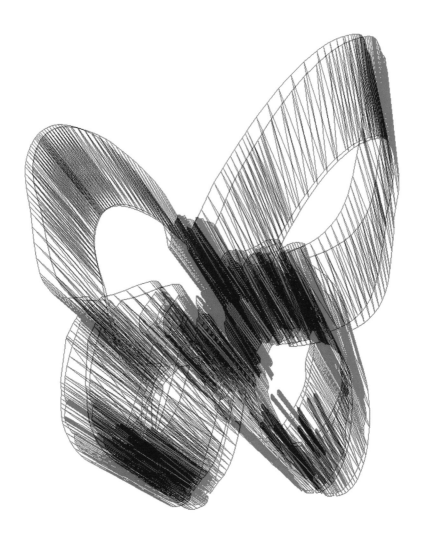

Filter

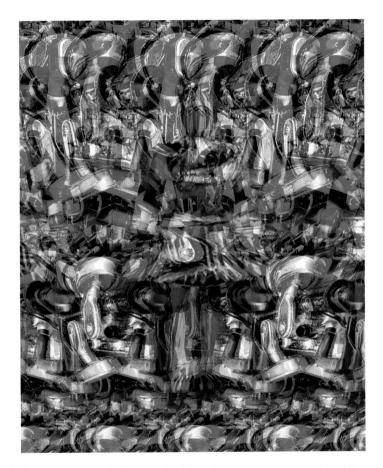

This image, made from a hidden-image stereogram, is unique.

Gold Eye Sky

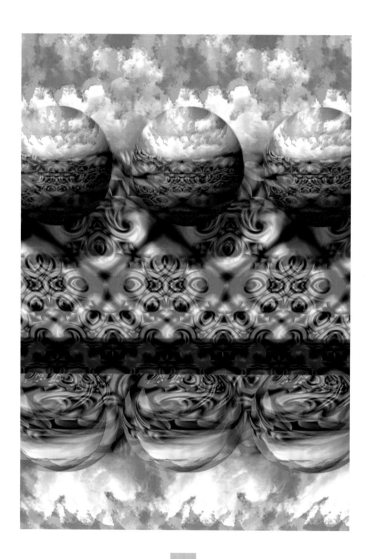

Holding Pattern

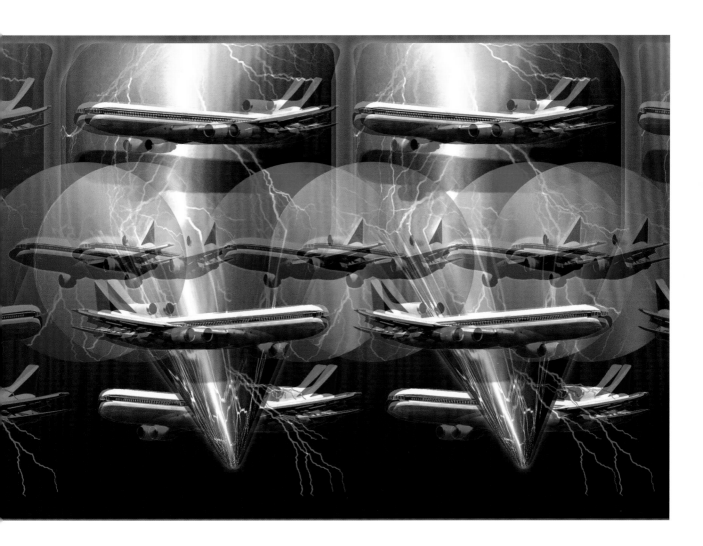

Wedgwood Blue

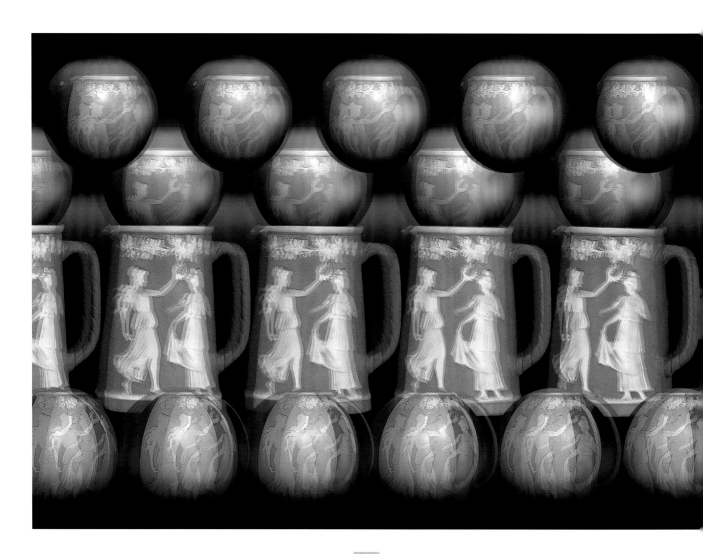

Parvati

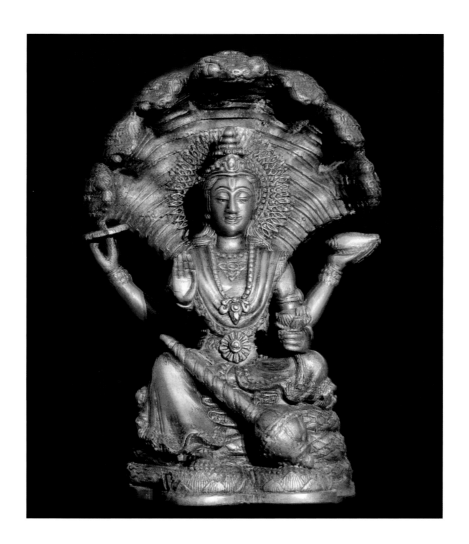

Stereo Time

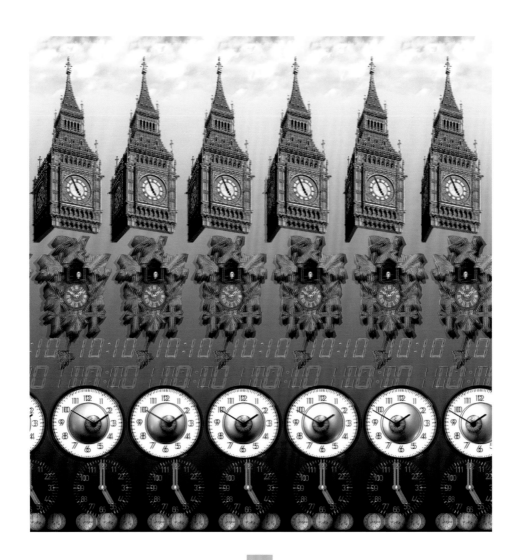

Anaglyph Machine

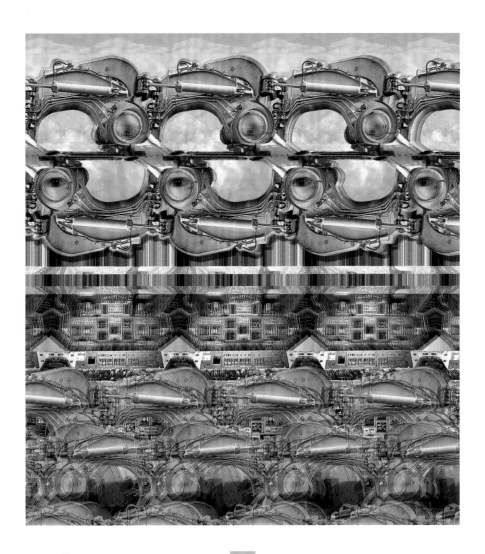

Vertigo Anaglyph

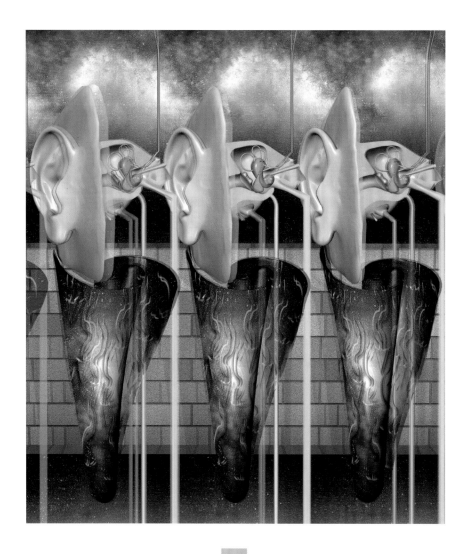

CHAPTER 3: STEREO PAIRS

From about 1860 until the 1920s, stereo-pair images became extremely popular, and a great many stereo-pair images were produced. These images were seen with the help of a stereoscope, which consisted of two mirrors that combined the two separate images so that the three-dimensional effect could be seen easily. In the twentieth century, Viewmaster produced millions of these popular stereo views seen through their patented stereoscope.

It is possible to see the three-dimensional effect by "free viewing" (without a stereoscope). View the two images by focusing not on the two images, but behind them. This will cause the images to separate and a third "middle" image should appear. When you get the "middle" image focused between the two outer images, then it will appear three-dimensional. Your mind's eye has combined the two different stereo views into one, and this produces the illusion of depth.

Antique Stereo View

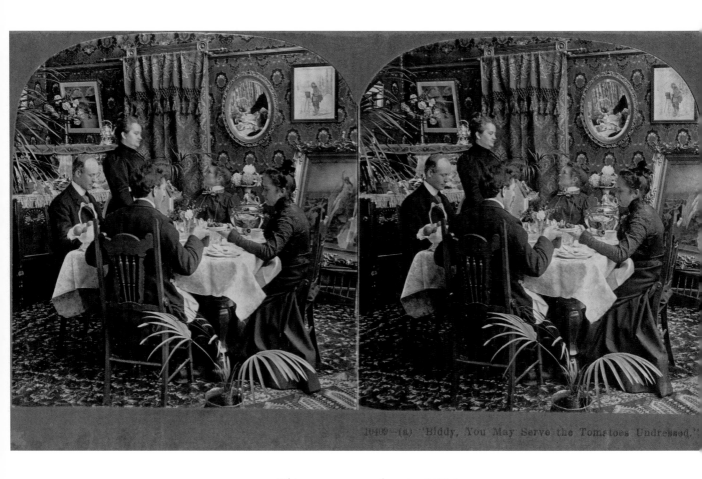

This scene was taken in 1896.

Stereo

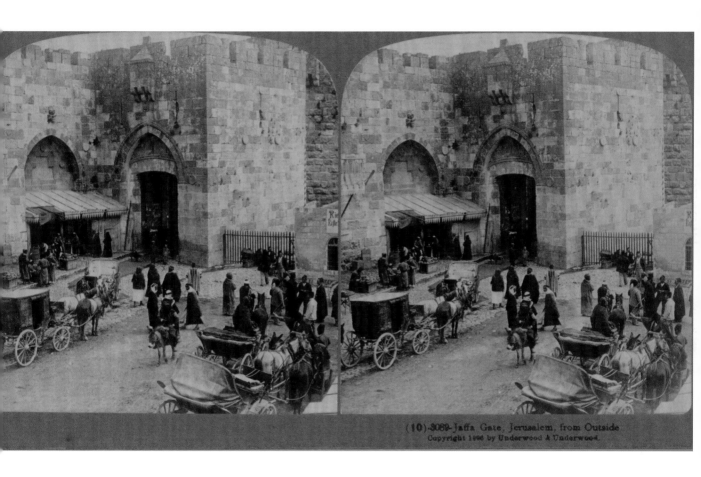

(10)-3089-Jaffa Gate, Jerusalem, from Outside
Copyright 1896 by Underwood & Underwood.

*Stereo views of exotic locations were extremely popular. This stereo pair
of Jaffa's Gate in Jerusalem was taken in 1896.*

Consegments

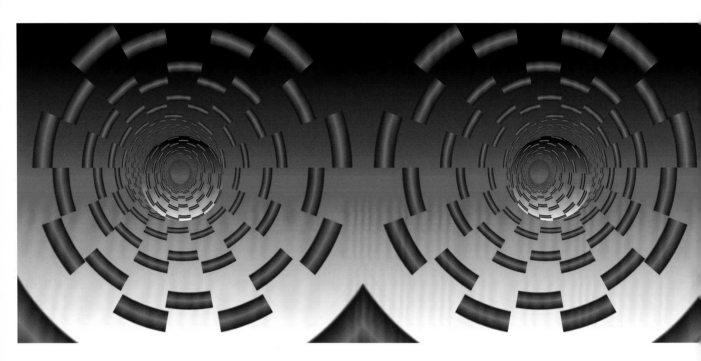

As you practice "free viewing" by focusing not on the two images, but behind them, a third "middle" image should appear. The "middle" image will appear three-dimensional.

Dizzy Daisy

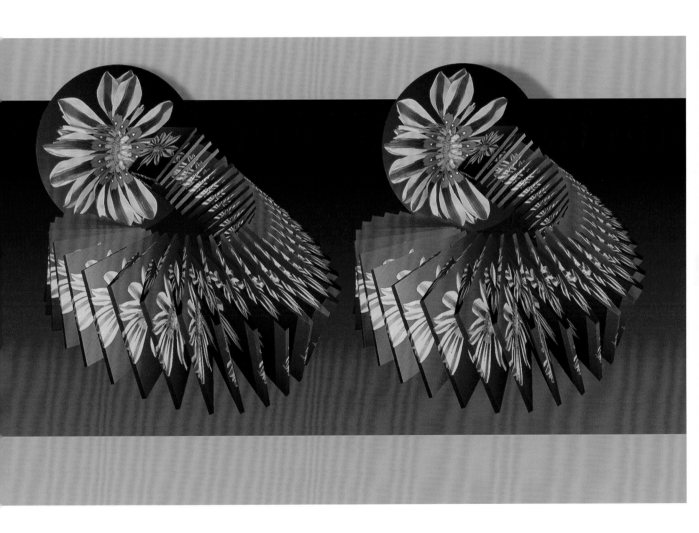

Nippon Della

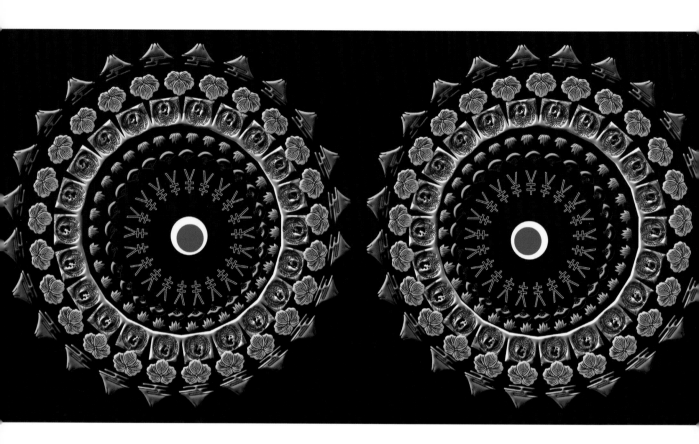

Shell Sette

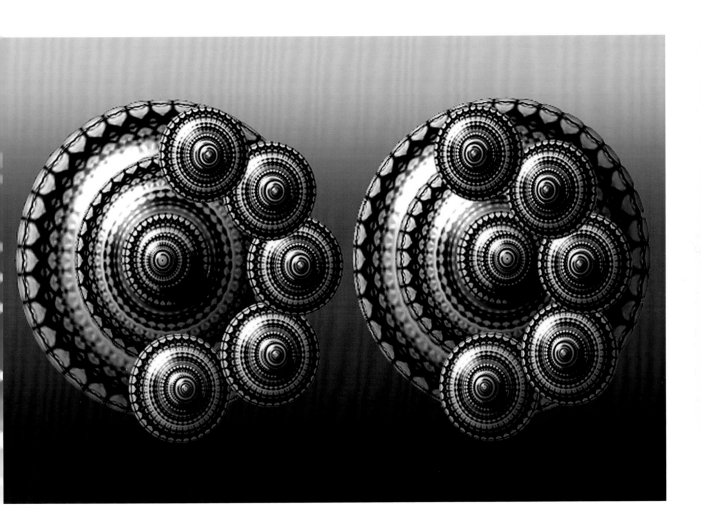

Shiela Spiral

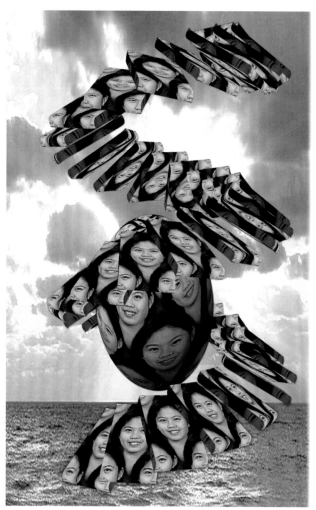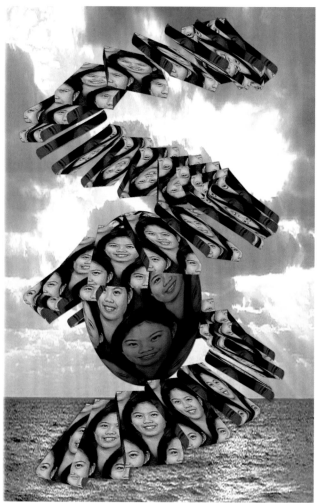

Sunset

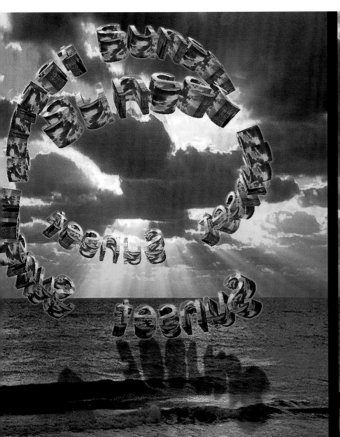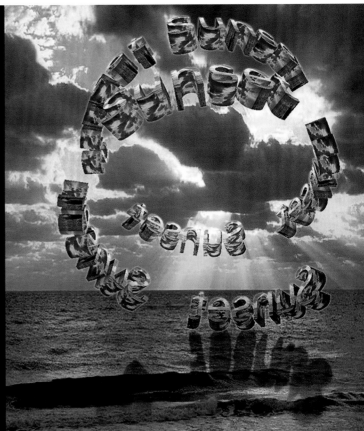

CHAPTER 4: HIDDEN-IMAGE STEREOGRAMS

All stereo pictures are designed so that they can be seen with a three-dimensional effect when the viewer uses what is called the divergence method. Your eyes must behave as if they are looking at something in the distance, focusing "behind" the image (exactly as far as the eyes are from the book). You must look at the image long enough for your brain to resolve the stereo information.

In hidden-image stereograms, you will see a pattern of "random image noise," which cleverly masks the stereo differences of a hidden image. When the image is resolved, the image will clearly appear to have depth and the hidden object will be resolved. You will definitely know when you are successful, because there is quite a delightful "AHA!" experience, especially when experienced for the first time. The effect is definitely worth the effort, so please keep trying. The "reveals" can be found starting on page 85 and are identified in the index. How to view in parallel style:

(1) These images work best under proper well-lit lighting conditions. It is difficult to view these effects in dim light. (2) Relax your eyes. (3) Pick a distant object and focus your eyes on it. (4) Slowly bring the 3-D picture up into sight, holding the book straight in front of you, but position your hands and the book slightly below shoulder level. (5) Continue focusing on the distant object. The idea is that you pretend to see through the three-dimensional picture by focusing on something in the distance. This may take some practice if you are trying this for the first time.

3D Grand Prix

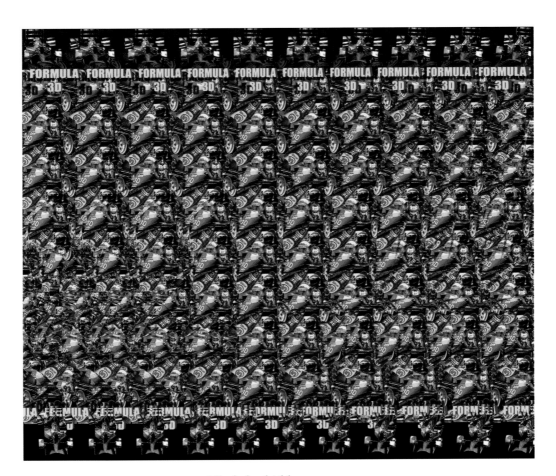

Find the hidden race car.

Assembly

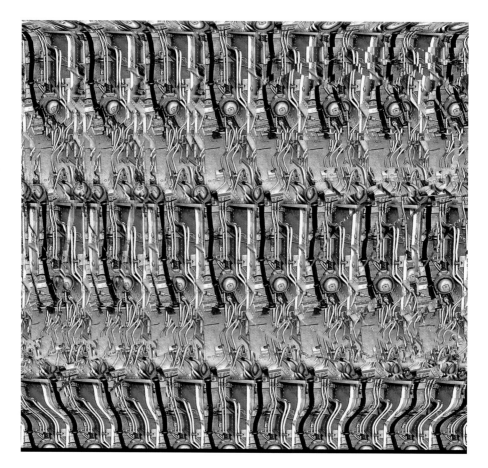

Find the robot.

Brain Scan

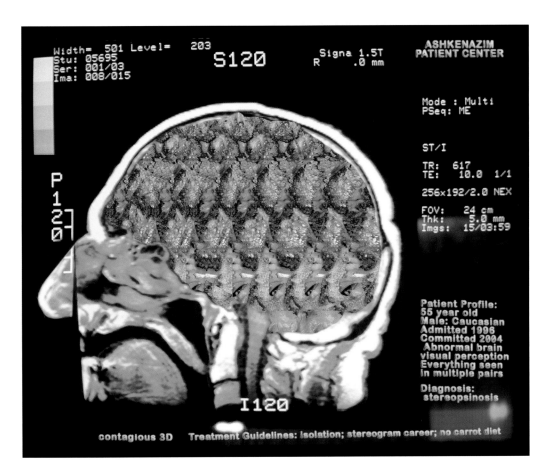

The characters "3D" are hidden in the brain.

Breakfast

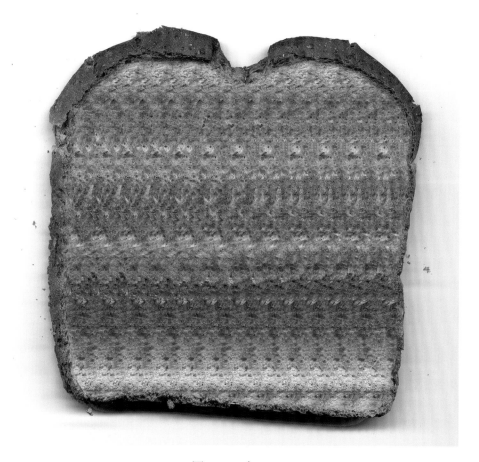

Toast and eggs.

Cat in the Grass

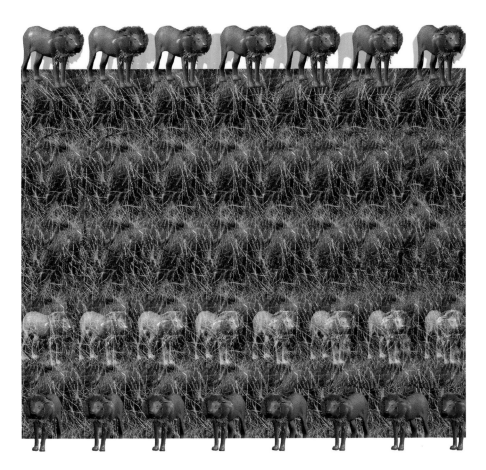

Find the large lion as well as the many smaller lions.

Cool Thermals

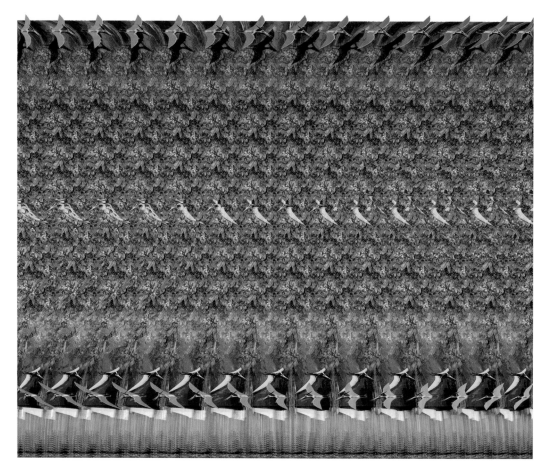

Find the hidden pterodactyl.

Deer Field

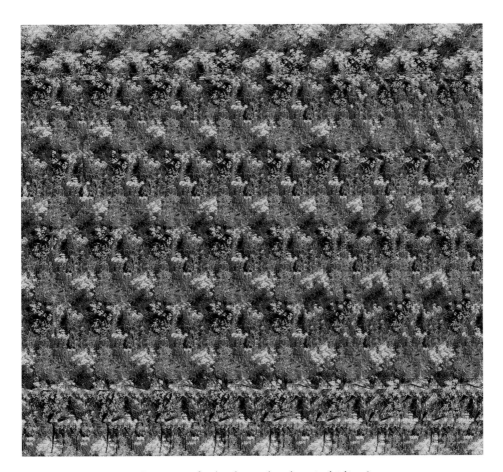

Can you find where the deer is hiding?

Dragonfly Sparks

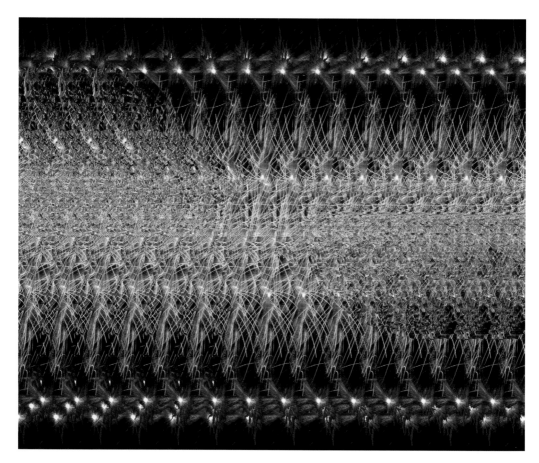

Can you find the dragonfly?

Footprints

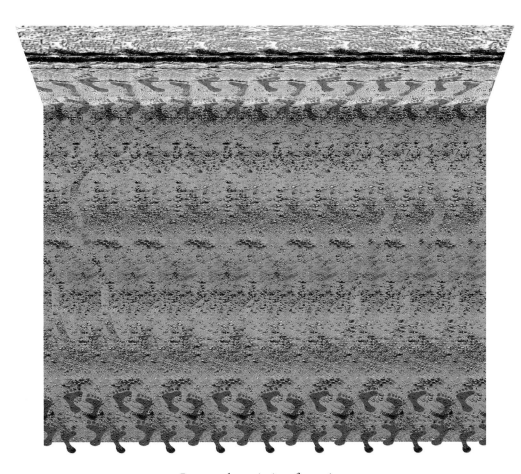

Locate the missing footprints.

Lake View

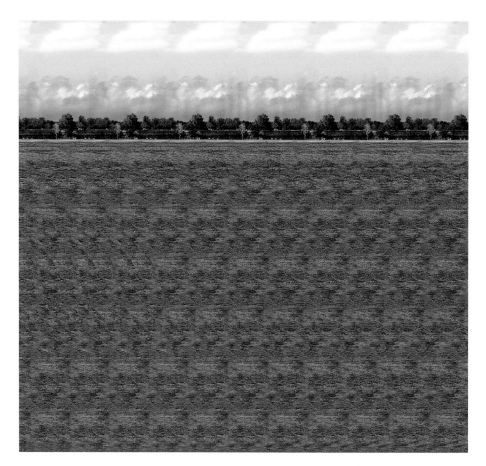

What is underneath the water?

Man & Woman

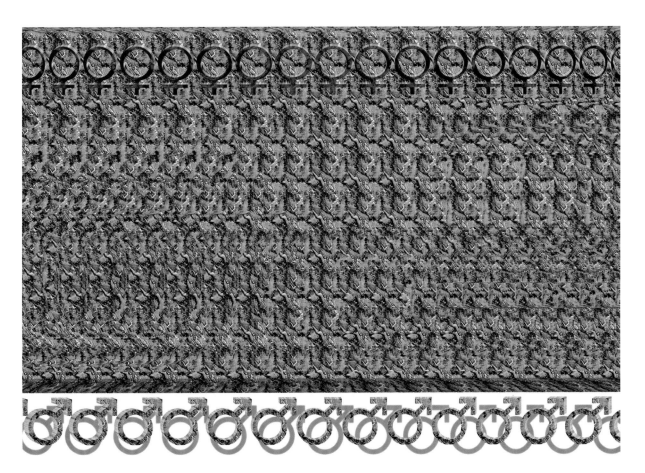

The symbols for man, woman, and yin and yang are hidden in this image.

Octopus

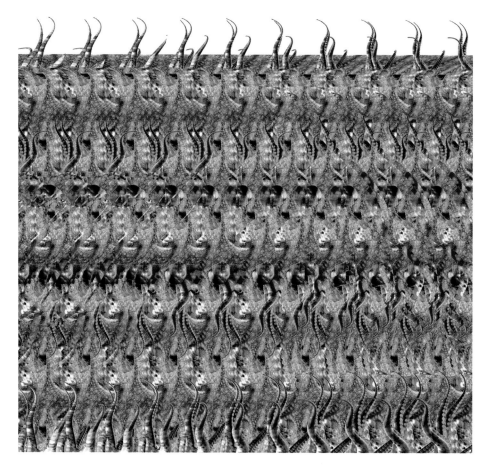

What sea creature is hiding here?

Overheated

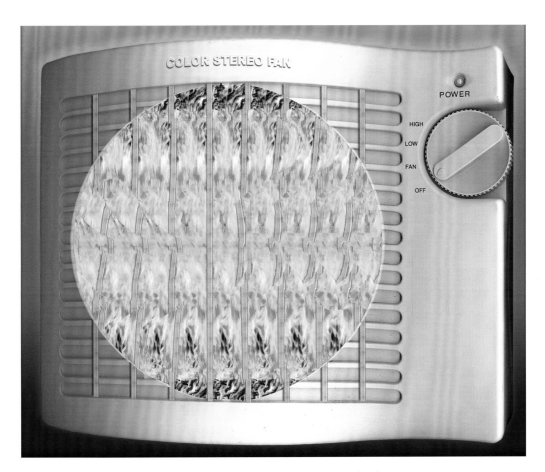

Can you find something to put out the flames?

Takeoff and Landing

Find the airplane.

The Cow Jumped Over the Moon

Can you see the cow jumping over the moon?

Camouflage

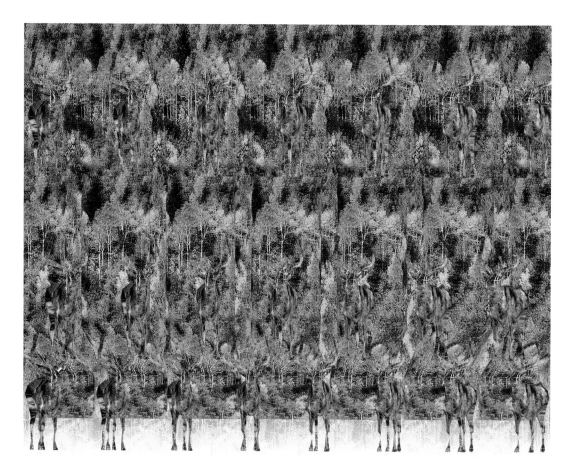

What animals are hiding in this image?

Shamrocks

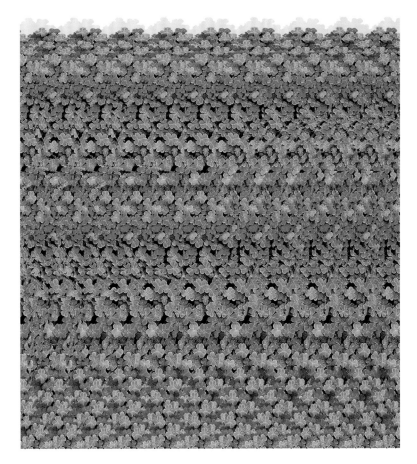

Can you find the lucky shamrocks?

Space Station

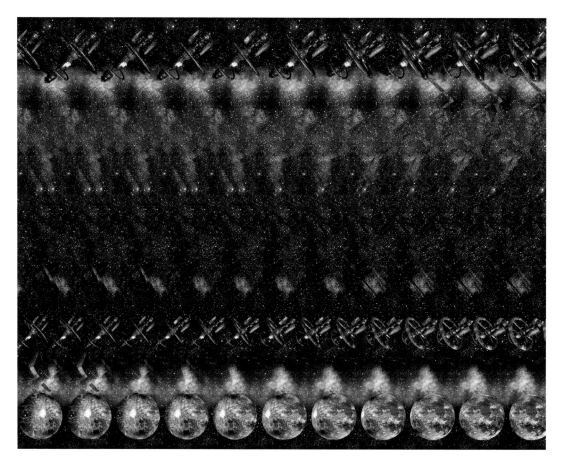

Can you find the space station?

Winter Trees

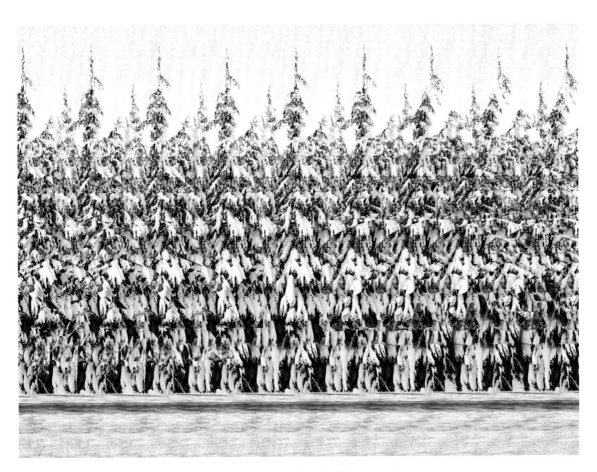

Can you find the hidden trees?

3D Leaves the Nest

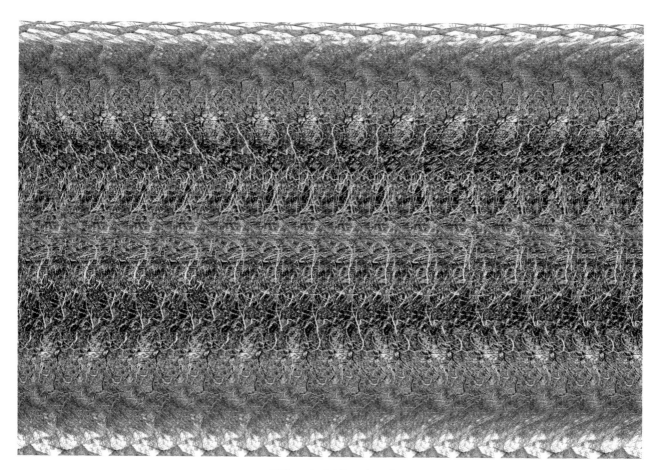

What is hiding here?

Dino Talk

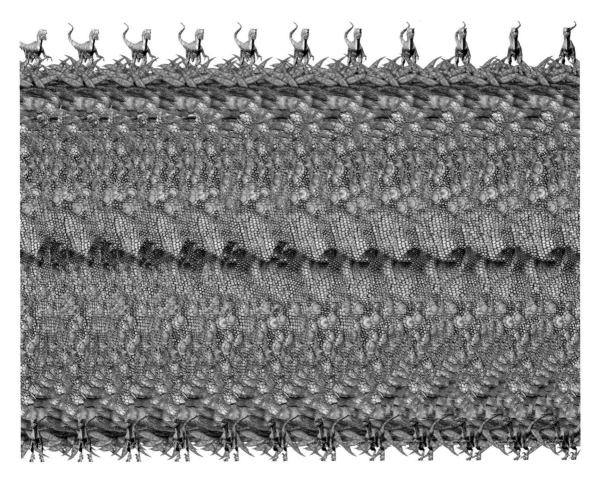

Can you find the talking dinosaurs?

CHAPTER 5: WALLPAPER ILLUSIONS

In the wallpaper stereo illusion, an image is repeated across the page, and when you use the same viewing technique as you did in the last chapter, you will see these images appear in depth.

Alpine Village

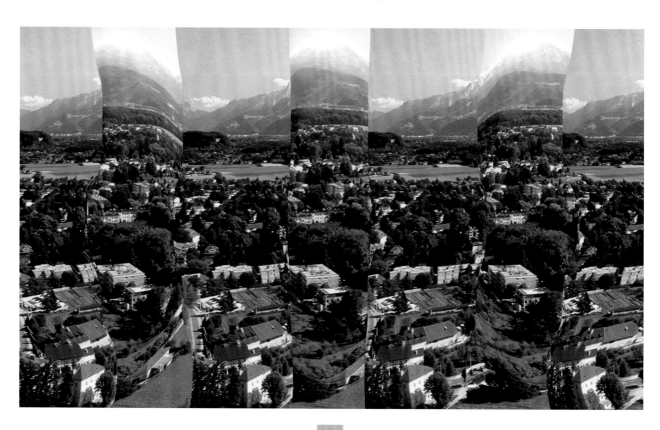

Bat Coins

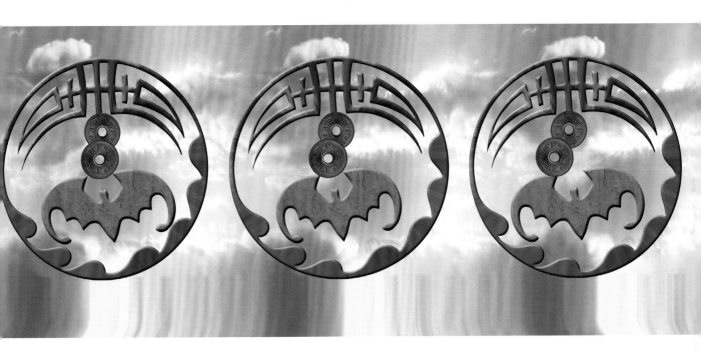

Butterfly Lines

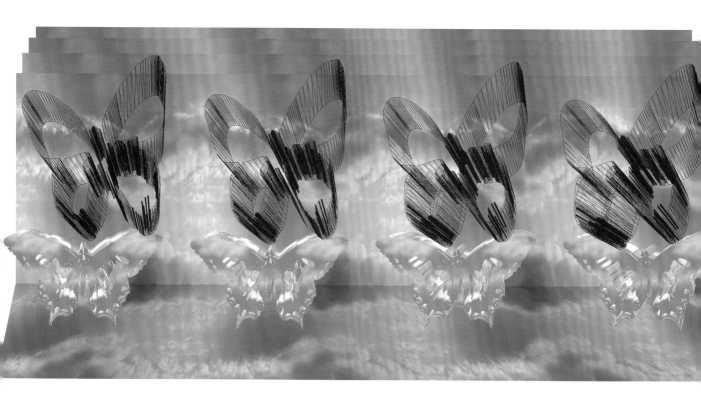

Chocolate Easter Hippos

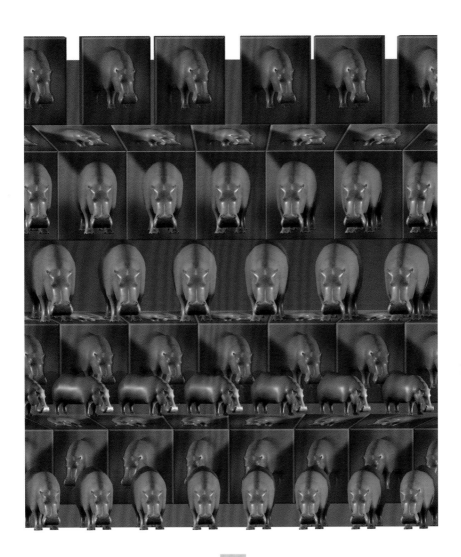

Clark's Dragon

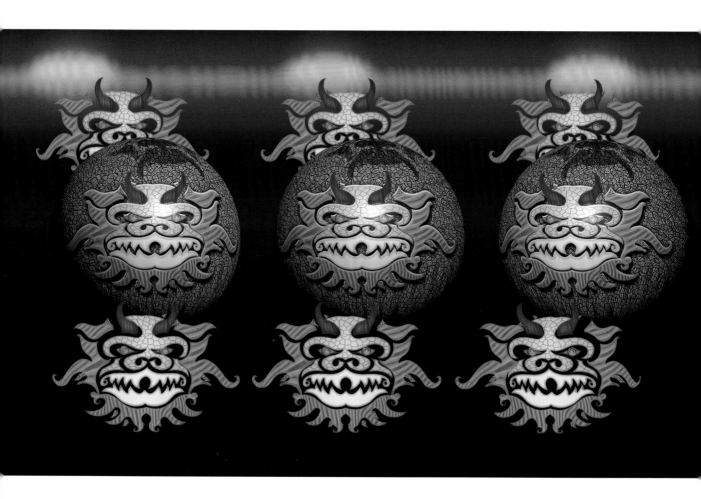

Dino Might!

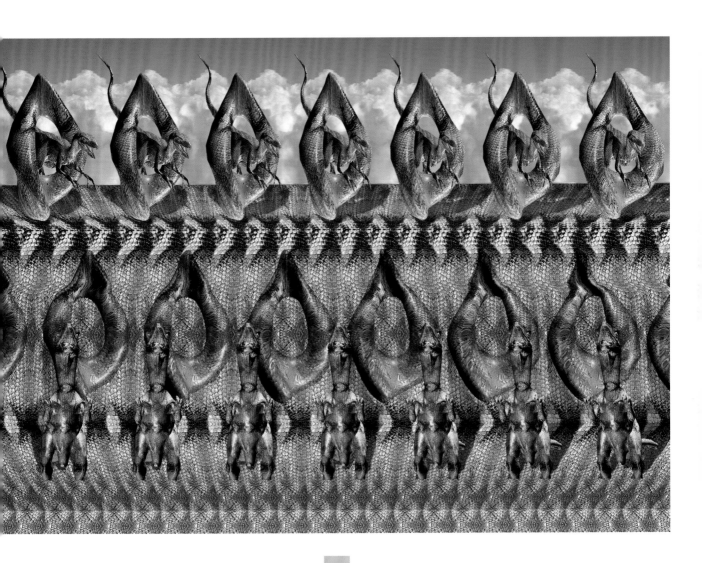

Disassembly

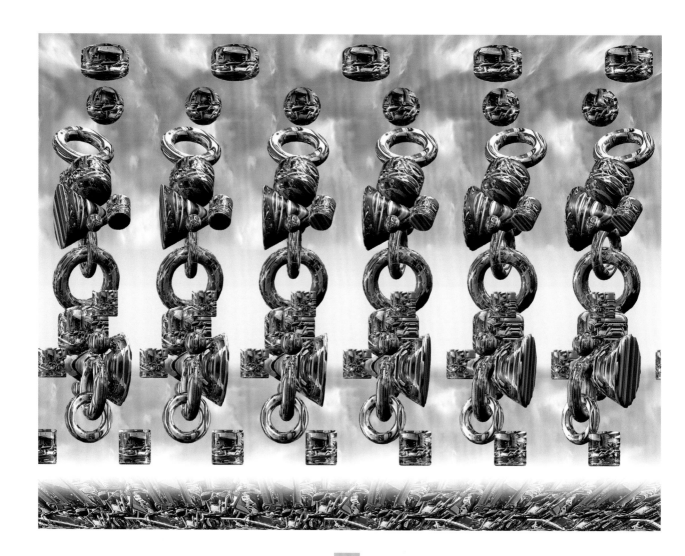

Eastern World

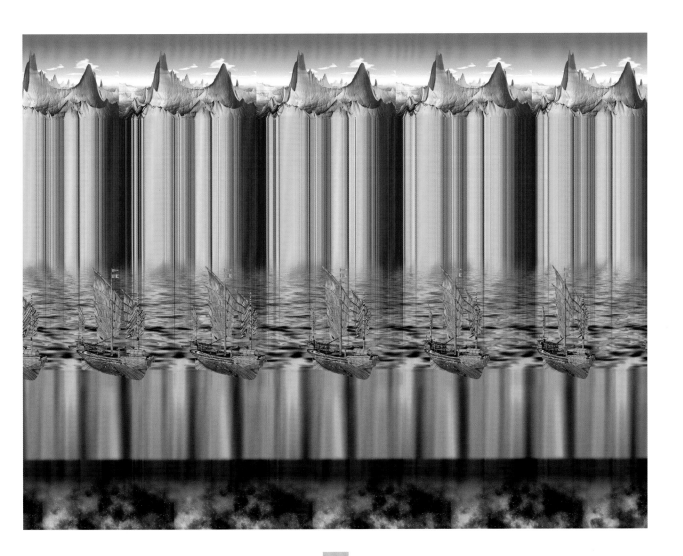

SUPER VISIONS: **Stereo Optical Illusions**

Eyesometrics

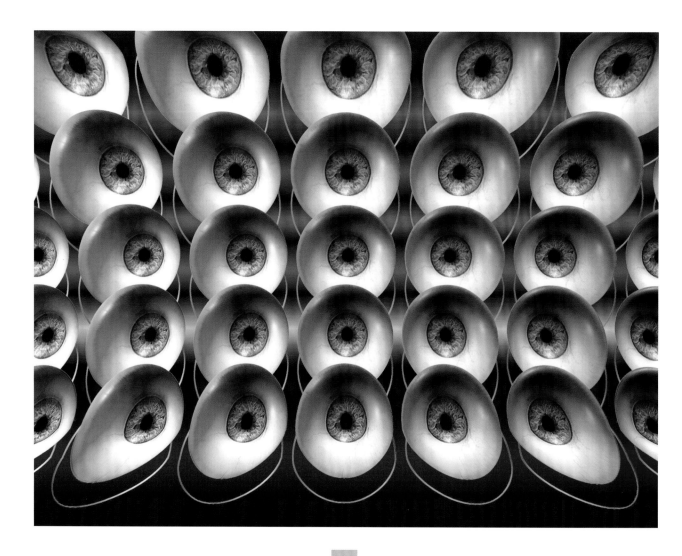

Hair Fit

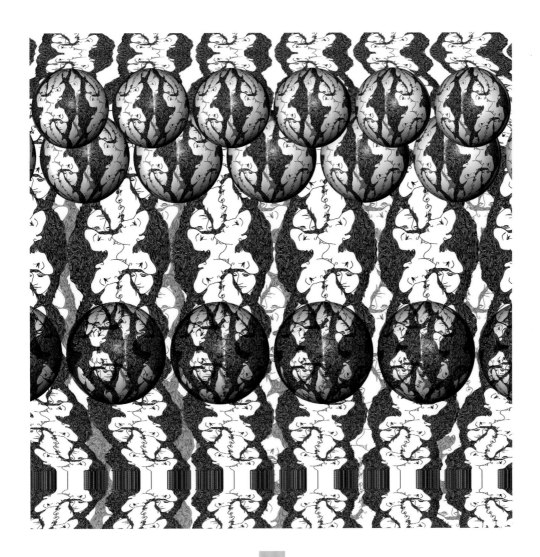

Hard Rock Menagerie

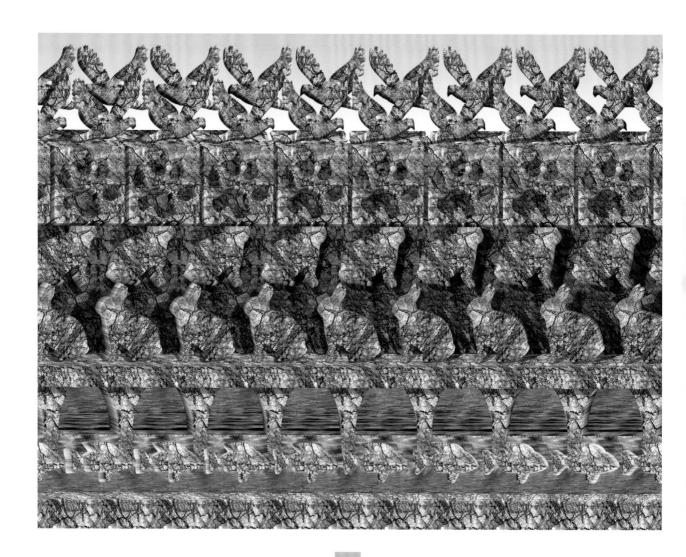

Koa Construction

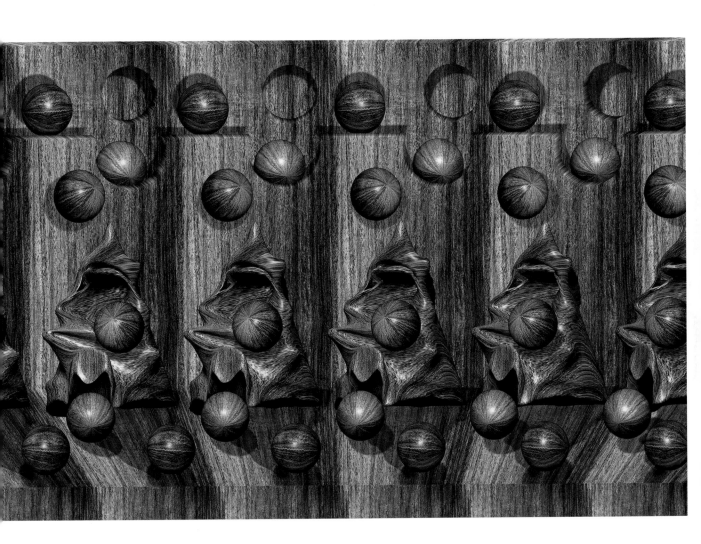

Lattice

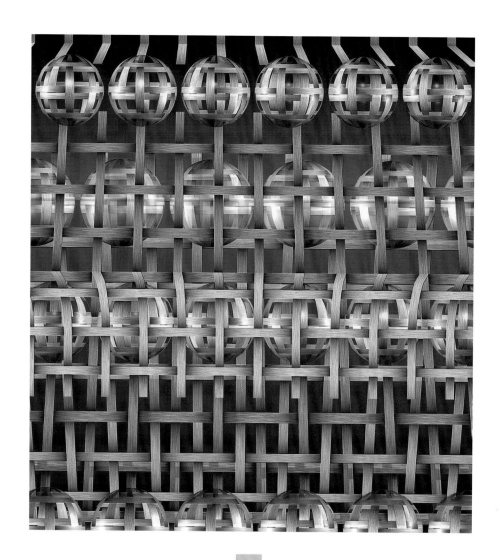

Stereo Rules

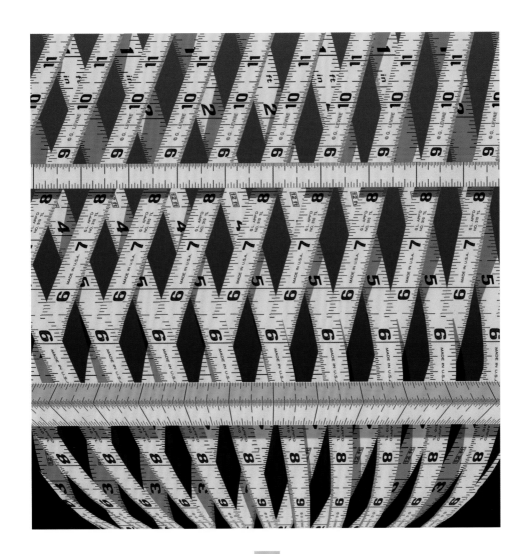

Stereogram Hotel

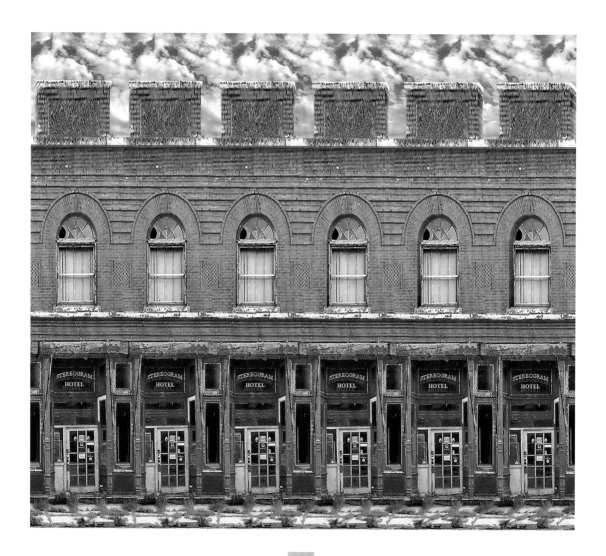

Stone Burst

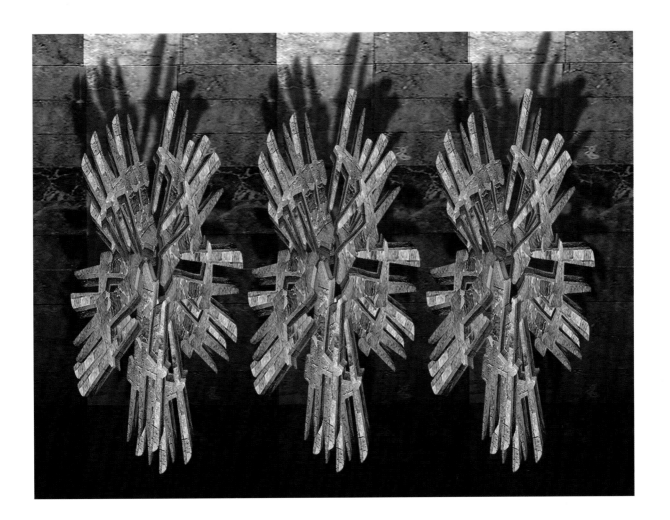

Velvet X

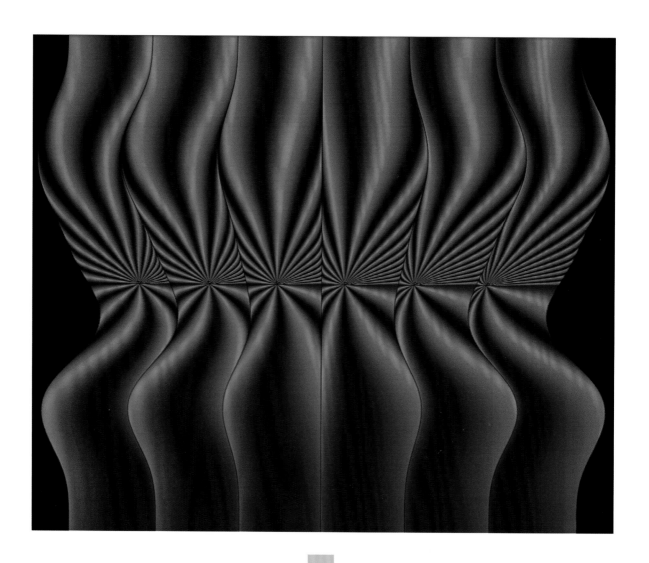

HIDDEN-IMAGE REVEALS

3D Grand Prix
(page 47)

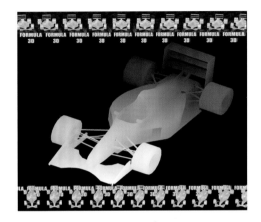

Assembly
(page 48)

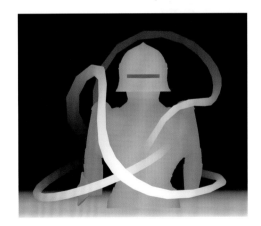

Brain Scan
(page 49)

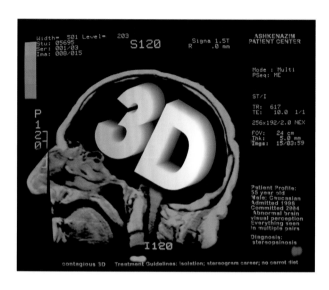

Breakfast
(page 50)

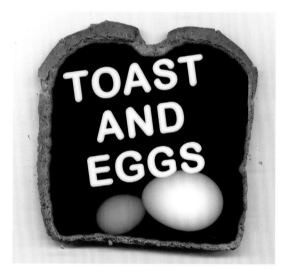

Cat in the Grass
(page 51)

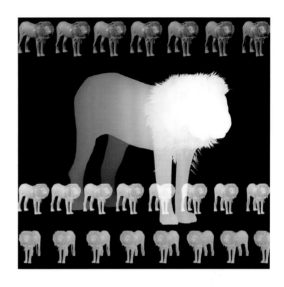

Cool Thermals
(page 52)

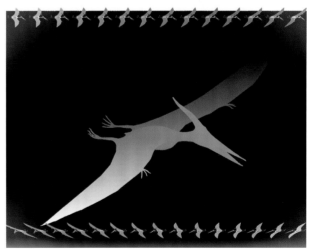

Deer Field
(page 53)

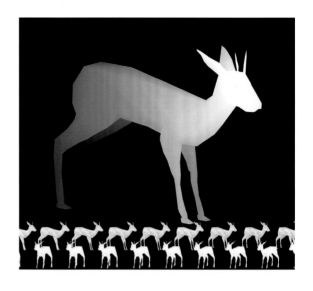

Dragonfly Sparks
(page 54)

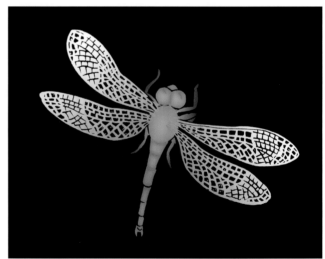

Footprints
(page 55)

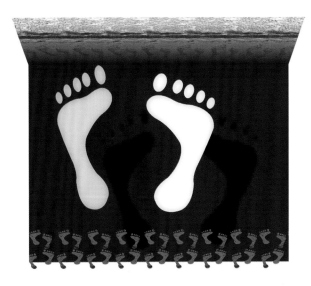

Lake View
(page 56)

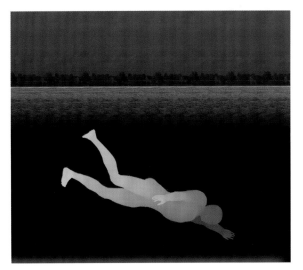

Man & Woman
(page 57)

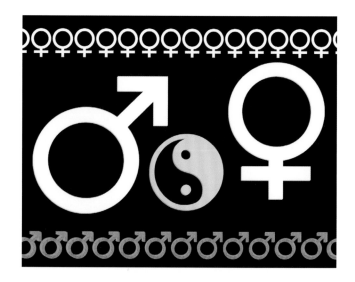

Octopus
(page 58)

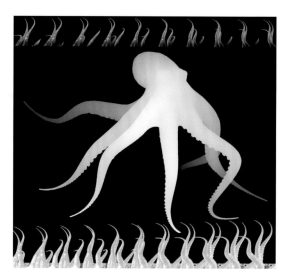

Overheated
(page 59)

Takeoff and Landing
(page 60)

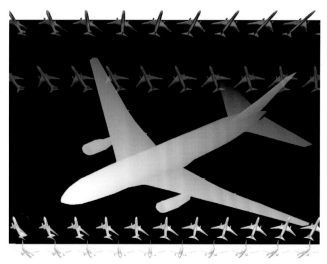

The Cow Jumped Over the Moon
(page 61)

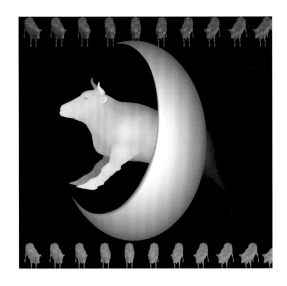

Camouflage
(page 62)

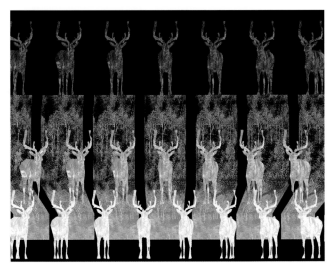

Shamrocks
(page 63)

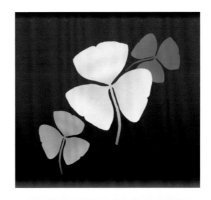

Space Station
(page 64)

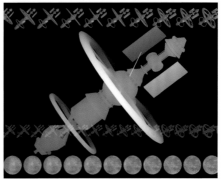

Winter Trees
(page 65)

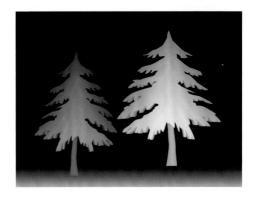

3D Leaves the Nest
(page 66)

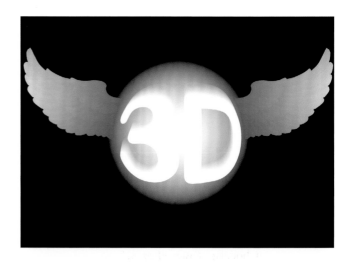

Dino Talk
(page 67)

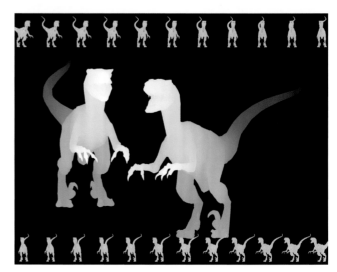

INDEX

ABOUT THE AUTHOR

Al Seckel is the world's leading authority on visual and other types of sensory illusions, and has lectured extensively at the world's most prestigious universities. He has authored several award-winning books and collections of illusions that explain the science underlying illusions and visual perception.

Please visit his website http://neuro.caltech.edu/~seckel for a listing of all of his books on illusions.

Other Sterling books by Al Seckel:

Masters of Deception: Escher, Dalí & the Artists of Optical Illusion
SuperVisions: Action Optical Illusions
SuperVisions: Ambiguous Optical Illusions
SuperVisions: Geometric Optical Illusions
SuperVisions: Impossible Optical Illusions
SuperVisions: Topsy-Turvy Optical Illusions